DIRTYING THE PAPER DELICATELY

INAUGURAL LECTURE

DIRTYING THE PAPER DELICATELY

Stephen Farthing R.A.

Rootstein Hopkins Professor of Drawing

University of the Arts, London

Tuesday April 26th 2005

UNIVERSITY OF THE ARTS
LONDON CAMBERWELL COLLEGE OF ARTS
CENTRAL SAINT MARTINS COLLEGE OF ART
AND DESIGN CHELSEA COLLEGE OF ART AND
DESIGN LONDON COLLEGE OF COMMUNICATION
LONDON COLLEGE OF FASHION

Text and images Copyright © Stephen Farthing 2005

Cover photograph: *Wind Blown Snow Amagansett, January 05* Stephen Farthing

Edited by Nigel Matheson

Designed by Roger Walton

Printed in the UK by Furnival Press, London

ISBN 1-87054-019-0

As the first recipient of the Rootstein Hopkins Chair of Drawing,
I would like to thank the Rootstein Hopkins Foundation and the
University of the Arts, London for their inspired support.

The challenge will be not simply to become a professor of drawing
within the frame of my own discipline, fine art, but for me to
explore and try to make sense of a much bigger picture, the picture
of drawing that can be found embedded within each of the activities
of this University of the Arts and beyond.

This essay sets out to map the foothills of the territory I expect
to explore.

DIRTYING THE PAPER DELICATELY

An activity that embraces not just invention, tactility, immediacy and economy but also repetition, cool copying and precise measurement.

INTRODUCTION

What I like about pens and pencils, *the simplest of drawing materials*, is their seamless ability to bridge hand and paper and, in doing so, to link writing to drawing.

This said, computers have now changed our methods of harvesting, handling and generating both images and text and our relationship with pencils, ink and paper for ever.

With this in mind, I would like to use a short extract from Tom Wolfe's essay, *Digibabble, Fairy Dust and the Human Anthill*,[i] to position us in time.

"The scene was the Suntory Museum, Osaka, Japan, in an auditorium so modern it made your teeth vibrate. In the audience were hundreds of Japanese art students. The occasion was the opening of a show of the work of four of the greatest American

illustrators of the twentieth century: Seymour Chwast, Paul Davis, Milton Glaser, and James McMullan, the core of New York's fabled Push Pin Studio. The show was titled *Push Pin and Beyond: The Celebrated Studio That Transformed Graphic Design*. Up on the stage, aglow with global fame, the Americans had every reason to feel terrific about themselves.

Seated facing them was an interpreter. The Suntory's director began his introduction in Japanese, then paused for the interpreter's English translation.

'Our guests today are a group of American artists from the Manual Age.'

Now the director was speaking again, but his American guests were no longer listening, they were too busy trying to process his opening line. *The Manual Age . . . the Manual Age . . .* The phrase ricocheted about inside their skulls . . . bounced off their pyramids of Betz, whistled through their corpora callosa, and lodged in the Broca's and Wernicke's areas of their brains.

All at once they got it. The hundreds of young Japanese staring at them from the auditorium seats saw them not as visionaries on the cutting edge . . . but as woolly old mammoths who had somehow

wandered into the Suntory Museum from out of the mists of a Pliocene past . . . a lineup of relics unaccountably still living, still breathing, left over from . . . *the Manual Age!*"

The last twenty years have clearly brought a mass of very attractive, user-friendly and relatively inexpensive new technologies to the draftsman's studio. The jury, however, I believe is still out on two important questions:

To what extent has this new technology changed

- The way we go about harvesting, manipulating and presenting information?

- Our ability to relate words and images?

Within these large questions, a series of smaller, but no less important questions emerges:

What are the important differences between

- Purely hand-made and mechanically assisted drawings?

- A keyboard and mouse, and a pot of glue, a scalpel and a pen?

- Working with given software and learned manual skills?

- Images captured through a lens and those captured by eye, then recorded by hand without a mechanical interface?

What I am certain of is that, over the past decade, technology has impacted on our perception of what drawing might be, and the challenge we now face is understanding how.

As interesting as this challenge is, it is not my immediate priority; more important is something more remedial.

The priority, I believe, is first to build a better definition of drawing, then establish where what I see as the bigger picture of drawing begins and ends.

Then with a better understanding of the size and shape of our subject, we can start to answer some old questions and frame some new ones.

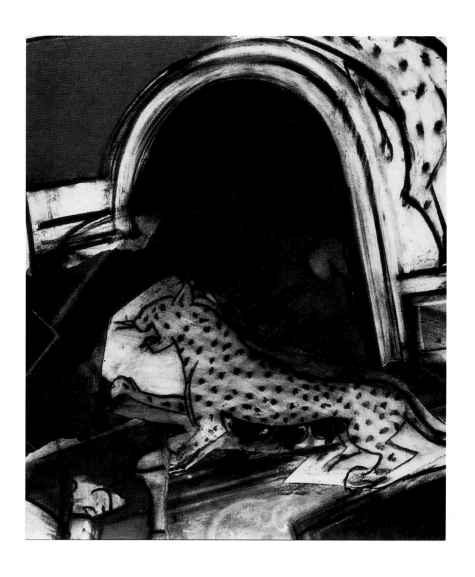

Illustration 1

TRACKING → 2.2#
BPD.

Wheel tracks
Skid Marks
Skiing → water – snow
(snow plough;)

COPIES – COPIES COPIES COPIES

CARTOONS
CARICATURE.

collage Montage!
frottage
CROMAGNUM
ANIMALS — Roman
Sarcophagus paints

CRO
MAGNU

DRAWINGS FROM
LIFE
Rembrandt
Matisse Friend.

Illustration 2

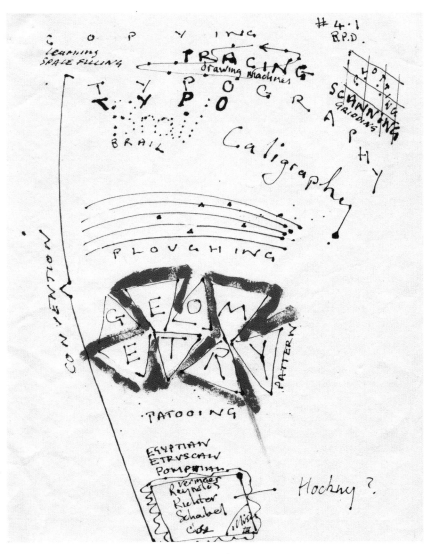

Illustration 3

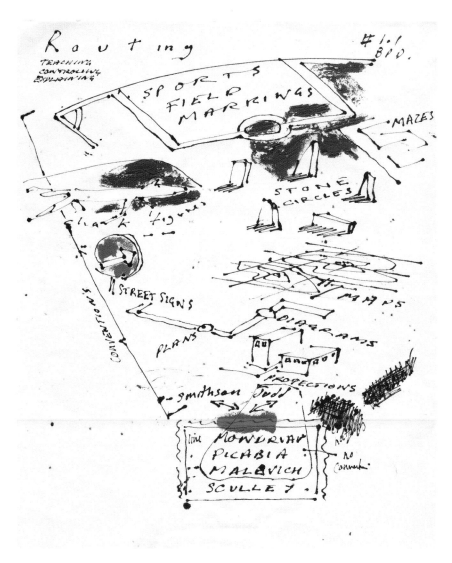

Illustration 4

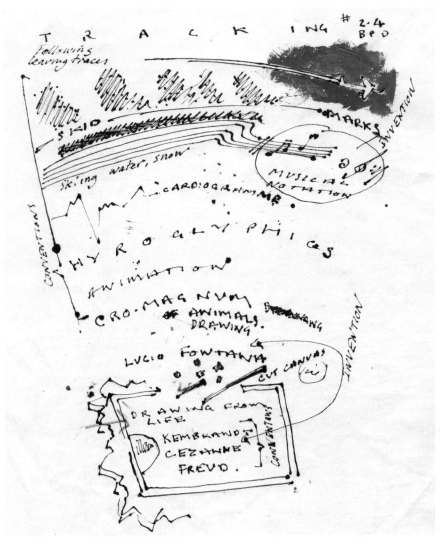

Illustration 5

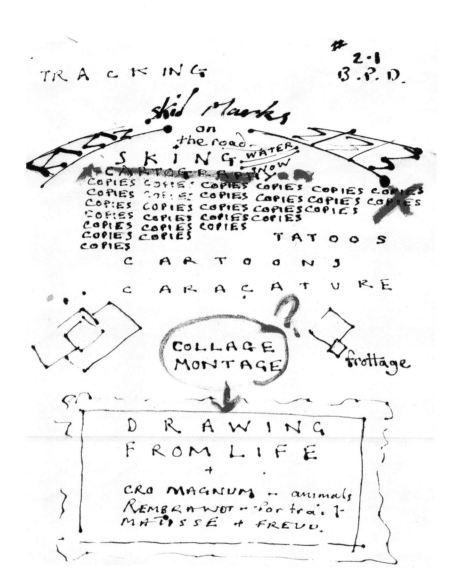

Illustration 6

16

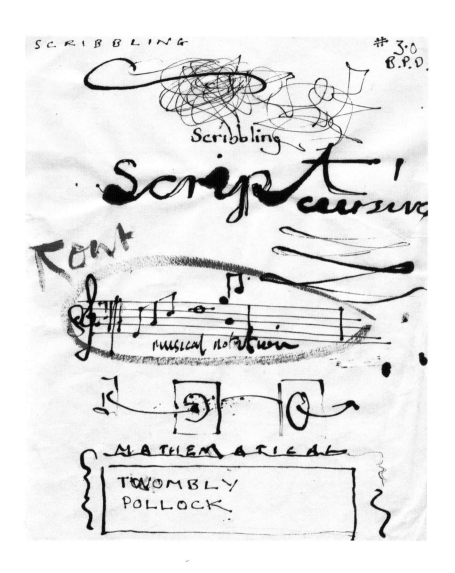

Illustration 7

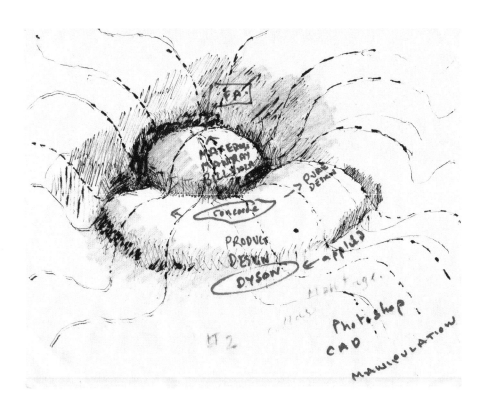

Illustration 8

18

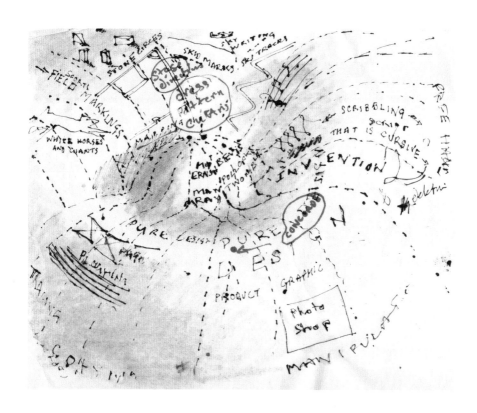

Illustration 9

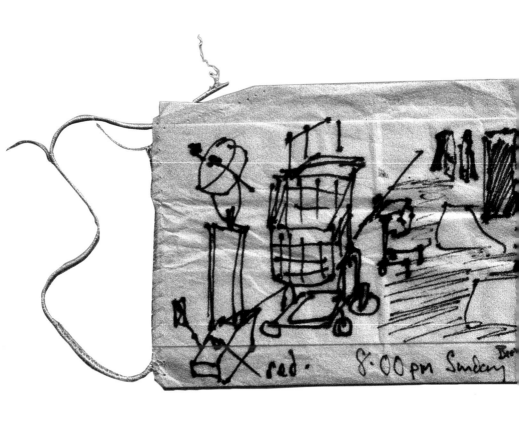

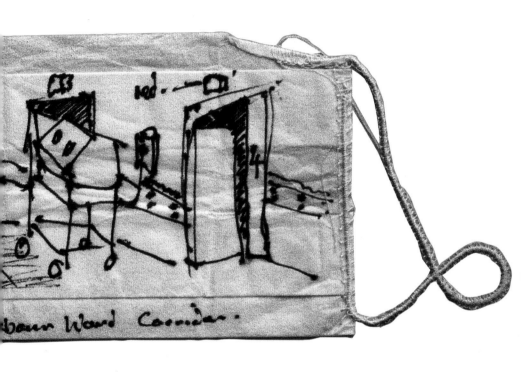

Illustration 10

21

DIRTYING THE PAPER DELICATELY

A unique work of art on paper

My title, 'Dirtying The Paper Delicately', is John Ruskin's elegant summary of the activity we call drawing.

Towards the end of the twentieth century, the American artist Brice Marden, with I suspect very different outcomes in mind, arrived at a remarkably similar conclusion, when he said, "The hand touches more delicately in drawing," a statement he qualified by saying, "There is less between the hand and the image than in any other medium."

At about the same time, John Elderfield, who was director of the Department of Drawings at the Museum of Modern Art in New York, took a less lyrical and, at first sight, more practical tack when he wrote, "Of all our modern arts, drawing is most resistant to definition."[ii]

In the same essay, he then went on to compound what I saw at the time as a complete abdication of responsibility, when he reminded the reader of his museum's neat and archivally expedient definition of a drawing, "a unique work of art on paper",[iii] a definition that to my mind falls a long way short of even scratching the surface of this massive subject.

At the time I can remember being irritated by both of Elderfield's propositions; today, however, I find myself not so much irritated as wondering why. Why the Museum of Modern Art's insistence on paper? Why Elderfield's belief that drawing is so resistant to definition?

While I understand both John Ruskin and MOMA's attraction to paper as part of a definition of drawing, I suspect that in the end materials alone, attractive as they are, do not hold the key to a definition.

In 1994, Michael Craig Martin wrote an essay for another Arts Council of England exhibition of drawing[iv] where he also avoided hard and fast definitions and instead offered a check list of qualities he felt all good drawings should possess:

"... spontaneity, creative speculation, experimentation, directness, simplicity, abbreviation, expressiveness, immediacy, personal vision, technical diversity, modesty of means, rawness, fragmentation, discontinuity, unfinishedness and open-endedness."

His list, which I have no argument with, leads me towards something Mark Francis[v] wrote when he was trying not so much to define drawing as to break it down into categories.

"Technical drawings, or working drawings made for sculpture, for instance, are believed to be precise, 'economic', and thereby to evince a kind of rational truth. Expressive drawing, on the other hand, is loose, or 'spendthrift', having a kind of emotional authenticity made evident by the traces of the artist's hand."

A collection of measurements

The part Mark Francis describes as "economic" and concerned primarily with measurement is, I believe, the relatively easy part to describe, teach and practise because the recording of measurements within well-defined conventions is a fairly uncomplicated task.

Francis chose technical drawings made by sculptors to illustrate his point because he was writing about drawing within the confines of fine art. If, however, I stretch his definition to include maps, pattern cutting, drawn plans and elevations, signage, designs for type-faces, the markings on tennis courts and even nineteenth century academic tonal drawings of plaster casts, which I suspect don't have any more to do with fine art than cartography, it still works perfectly.

The drawings in question can be *about* or *of* anything, but what they all have in common is that, in the final analysis, they are **a collection of measurements**.

Whether they are motivated by a desire to make concrete an idea or the image of something that already has an established physical presence, their point is to collect and record the measurements which shape that event.

These measurements can either be estimated as, for example, in a drawing of Catherine Lampert by Frank Auerbach, or made with an instrument as they are in a Sol Lewitt wall drawing or a recent portrait drawing made with a *camera lucida* by David Hockney.

Unfinishedness

What is both more difficult to explain and **do** is what Francis describes as the "spendthrift" side of drawing. The speculative, inventive side, the side where ideas can be born and buried in seconds, and luck and inspiration mingle with frustration and, on very rare occasions, genius.

As a way into the intangibility of the "other" segment of drawing, the part that Craig Martin's check list concentrates on, I would now like briefly to consider **unfinishedness** which for me sits quite happily with "open-endedness".

Drawing is the only language I know where unfinishedness is so deeply ingrained and accepted, not just as a part but as a positive attribute of a language.

The upside of accommodating this quality is that it enhances the power of the language by adding to it an ability to provide a welcoming space for dreaming, self-expression, informality, wrestling with the unknown and acknowledging quite openly, and without breaking continuity, gaps in the maker's knowledge.

The downside is that "unfinishedness" complicates the language to such an extent that both "reader" and draftsman are obliged to use their imagination, intelligence and resourcefulness if they are to make sense of what is before them. In short, it makes for an interesting but often difficult "read".

Drawings knowingly made within this frame are made in the spirit of private journal entries and letters to dear friends. An intellectual curiosity, self-confidence and wit are all prerequisites of learning to draw open-endedly, and with "unfinishedness". In this way, learning to build the sophistications Michael Craig Martin has in mind into the language of drawing is not just a question of learning a few tricks and "off you go", so to speak; it is a long and complex haul that will be more concerned with the development of intellectual curiosity, confidence, wit and imagination than the acquisition of technical skills.

So when John Elderfield talks about the elusive nature of drawing, I suspect it is the speculative and expressive, not the "measured", he finds so difficult to pin down.

Grey areas

With the *measured* on one hand and the *expressive* on the other,
it may appear that I am beginning to produce a rather
black-and-white image, but there are of course very interesting greys
that don't fit comfortably into either of the categories.

In 1503–4, in pen and ink over black chalk, Leonardo da Vinci drew
the river Arno and its tributaries as they sat in the country around
Pisa,[vi] with a proposed route for a canal drawn through it.

Within what I can best describe as a deluge of expressive and
aggressively drawn lines, swirls, bleeds and blots, there is both a
mathematical scale and a cluster of carefully written technical notes
describing the potential for the canal to silt.

This drawing seems at first sight to be some kind of abstracted
psychological battle field; with time to look, it becomes possible to
unfold it as a well thought through technical plan for the
canalisation of a river. What places it in the grey zone is the thinking
that went on during its making as a working drawing and the hand
of the maker, not its subject matter or purpose.

Within the grey area, there are also the blackboards that are used in universities, laboratories and learned societies to work out and explain ideas, concepts and theorems. Within the history of these boards, one interesting example has been preserved for posterity, the one used by Albert Einstein to explain some aspects of the age and expansion of the universe to the University of Oxford after receiving his honorary doctorate in May 1931.[vii]

When we look at this board today, I suspect we look forensically at every mark in a bid to understand not the equations or the concept Einstein was explaining, but to try and understand more about the maker. This is a viable quest if indeed Brice Marden is right and there is less between the hand and the paper than in any other medium.

THE BIGGER PICTURE

From mathematicians to groundsmen

When I was a student of painting at Saint Martins in London in 1970, the art historical picture of drawing I was given started on a grey cave wall and ended on a white gallery wall.

From the sketch pad and real life to the studio – where there were bigger sheets of paper and finally paints and canvas – was the pathway we were directed down.

Within this framework, I was clearly aware that others drew for reasons other than informing their paintings but it wasn't until as a postgraduate I went to study in Rome that I began to realize drawing was an activity that was neither owned nor monopolized by

fine artists, and that drawing could be an end product in itself – not simply a throwaway vehicle for getting to more grand and permanent resolutions.

The landscape of drawing unfortunately gets more complex through time. At the start, there are tracks and traces left in the sand and on rocks, some willfully made, others inadvertently left. At the start, there is a hunter gatherer leaving images on the wall of a cave, then very gradually more specialist user groups accumulate: mathematicians, cartographers, scientists, then designers, statisticians, even groundsmen drawing the lines on sports fields. Each group takes the conventions of a shared language in different directions, but none, I suspect at this stage, very much changes the core purpose of drawing.

There are two artists whose work is central to our understanding of the bigger picture I am beginning to describe: Leonardo da Vinci and Albrecht Durer, both famous as fine artists who also, as it happened, used drawing to advance our understanding of a whole range of disciplines, including science, geometry, typography, mathematics, engineering and cartography.

From natural history to typography

Although probably best known for his realism, Durer used drawing to engage with a wide range of more speculative and intellectually challenging activities than simply impressing his audience with an obsession for detail.

In 1512 for example, he drew a freak of nature, The Ertlingen Siamese Twins, with a loose and informal hand that showed very little detail.[viii] In 1515, from another artist's notes, he drew the Indian rhinoceros[ix] that was lost at sea while on its way as a gift from King Manuel of Portugal to Pope Leo X in Rome.

Towards the end of his life, he published a four-volume treatise on mathematics in which he set out methods for using a ruler and a compass to construct and "draw" curves, regular polygons, platonic and semi-regular Archimedean solids. In true Renaissance style, Durer included his designs for the Times Roman type-face that we still use today.

Picasso at the Lapin Agile

Steve Martin, actor, writer and art collector, tackles this issue head on in his one-act play, *Picasso at the Lapin Agile*.[x]

The action takes place three years before Pablo Picasso painted *Les Demoiselles d'Avingon* and just a year before Albert Einstein published the special theory of relativity.

In 1904 Albert Einstein and Pablo Picasso, both still enjoying anonymity, chance upon each other in a Parisian bar, Le Lapin Agile.

In this short extract, Steve Martin grapples with the possibility that Albert Einstein and Pablo Picasso's drawings may have a lot more in common than Picasso or any of us imagine. Einstein is leaning on the bar; Picasso is dancing with Suzanne, a regular at the bar. Einstein overhears Picasso talking about drawing to Suzanne as they dance.

EINSTEIN: I work the same way. I make beautiful things with a pencil.

PICASSO: You? You're just a scientist! For me, the shortest distance

between two points is *not* a straight line!

EINSTEIN: Likewise.

PICASSO (*still dancing*): Let's see one of your creations.
(EINSTEIN *pulls out a pencil*. PICASSO *stops dancing, gets a pencil.*
The others back away as if it were a Western shoot-out.)

PICASSO: Draw! (*They start to draw on the napkins*. EINSTEIN
finishes first.)

EINSTEIN: Done! (EINSTEIN *and* PICASSO *swap drawings.*)

EINSTEIN: It's perfect.

PICASSO: Thank you.

EINSTEIN: I'm talking about mine.

PICASSO (*studies it*): It's a formula.

EINSTEIN: So's yours.

PICASSO: It was a little hastily drawn . . . yours is letters.

EINSTEIN: Yours is lines.

PICASSO: My lines mean something.

EINSTEIN: So do mine.

PICASSO: Mine is beautiful.

EINSTEIN (*indicates his own drawing*): Men have swooned on seeing that.

PICASSO: Mine touches the heart.

EINSTEIN: Mine touches the head.

PICASSO: Mine will change the future.

EINSTEIN (*holds his drawing*): Oh, and mine won't?

(*Sensing victory, or at least parity*, EINSTEIN *starts to dance with* Suzanne. PICASSO *stands befuddled*.)

THE LANDSCAPE OF DRAWING

The bigger picture of drawing is structurally like a three-dimensional, undulating pie diagram where slices of related activities take you from the edge to the centre. The image almost certainly has art at its centre, with design wrapped around it and a permeable interface between the two. *(Illustrations 8 and 9)*

Near one of its edges there are lots of handwritten notes, letters and manuscripts, musical notations and drawings on blackboards and, at the very edge, a million doodles on notepads left next to telephones.

In one of its margins, somewhere else on the picture surface, there are road and subway maps, plus architects' and engineers' plans for buildings and bridges. *(Illustrations 4 and 5)*

Nearby there are clusters of small white dots on indigo grounds that map the heavens, then, at the centre of that same segment, drawings that consist of slashes and punctures of pure surfaces which the Italian artist Lucio Fontana made in the 1950s.

There is another section running from edge to centre, that has sets of skid marks left in black rubber at its edge by stopping vehicles, near those sharp, fine black lines drawn on to seemingly never-ending rolls of graph paper made by oscilloscopes, cardiographs and barographs.

Somewhere around the middle of the picture, there are the more predictable aspects of drawing: a drawing made in a life class, a drawing of a tree by Mondrian, then a self-portrait by Rembrandt and another by Lucian Freud. *(Illustrations 2 and 3)*

The picture I am drawing with words is based on a series of images that I'm building in my studio. It is still in sketch form but what I know already is that it is rapidly growing, and what's clear already is that, like the strategy some use for working on jigsaw puzzles, it seems best to start by finding the edges.

The cursive

Not so far from the centre of the slice that contains writings, there are the drawings by Bruce Nauman and Cy Twombly, and at the very centre there are Jackson Pollock's drip paintings (which I view as drawings not paintings). *(Illustrations 6 and 7)*

About 50 years after Jackson Pollock died, Michael Butor, in an interview with Michael Reid,[xi] compared Pollock's approach in his late drip paintings to writing. Unlike many of his contemporaries, Pollock was not using thick pasty oil paint but liquid flowing paint, paint that was like ink.

"... paint that, when it was used in the way Pollock used it, created a thread that is close to handwriting."

Discussing the difference between writing that is created letter by letter and cursive writing, Butor positions Pollock as cursive and, by default, Beckman in the letter-by-letter category.

"We might say that Pollock's art rediscovers a kind of element-ary writing, but his stroke didn't take him as far as writing . . . he remains in what I call infrawriting, he remains a scribbler.

As part of the traditional writer's activities – assuming he must write by hand – there is often an escape towards a more liberated stroke, and that is scribbling. To scribble is to take possession of a space."

Having returned to this connection between writing and drawing and explored something of the breadth of the subject, I would like to consider just one other possibility.

The limbo of children

The very best drawings create within themselves a kind of limbo and, because of the way they are made, become safe, non-judgmental environments for the storage of information.

In 1975 while a student at the British school at Rome, I visited Tarquinia, a small town just north of Rome, and made just one charcoal drawing. This drawing is of the big slinky spotted cats that decorate the walls of one of the small Etruscan tombs that lurk beneath the fields outside the city.

I made just one drawing, *(Illustration 1)*, which has never been put

to work and, as a result, remains, like a holiday photograph or a picture in an image bank, as a record. There is no painting that followed, no subsequent drawings of similar subjects. The drawing, I now realize, led me nowhere, other than to keep it.

I kept it because I liked it. Today I still like the big slinky spotty cats. I like the way they are drawn, the spatial shift I have imposed between the cats and the wall they are supposed to be painted on. I like the darkness of the drawing and the narrative that implies.

Because I have never done another drawing that looks much like it and never had a desire to, it is so to speak a *one-off* that simply rests in its own space.

A space that Saint Thomas Aquinas eloquently described as "the limbo of children":

"... an eternal state of natural joy, untempered by any loss at how much greater their joy might have been, had they been baptized."

Which when translated into Artspeak[xii] about drawing becomes:

a poetic space where ideas, and information can be stored in a raw and untranslated state.

Another drawing that fits into this category I made in a hospital corridor on a disposable face mask at about 8pm on Sunday 7th August, 1983. *(Illustration 10)* I was sitting outside an operating theatre waiting for my daughter to arrive by caesarean section. There was no painting made from this drawing and there most likely never will be. The drawing made with pen and ink simply sits as a vessel which contains a little raw information.

In pursuit of the idea that drawings create a limbo for information to rest in, I tested the proposition against some examples from the bigger picture of drawing:

- The markings on the tennis court sit in limbo until they are activated by the arrival of the net and the players with their rackets and balls.

- The dress pattern is only activated once it is cut into fabric and the pieces sewn together.

- The architect's design sits in limbo until it is constructed – up until

then it is untempered by leaks, subsidence and the tests of time.

- The tonal study made by a student in the mid-nineteenth century at the Ecole des Beaux Arts in Paris could only be considered complete when the lessons learned in its execution were translated on into another work.

When Leonardo drew his imagined deluges, they were untranslatable and could not have been painted by him or any other painter of his time.

The information they contain, the extraordinary conceptual grasp he had of both the wrath of the gods and the elements, remains in a diagrammatic limbo. They were, however, partially released during the first half of the nineteenth century by Turner when he made discoveries within landscape painting that enabled him to engineer elemental images of the landscape that went some way towards addressing what Leonardo was approaching in his drawings.

Five hundred years after Leonardo made his deluge drawings, each one still contains information that remains fresh, raw and undigested, something that it is difficult to believe will ever be said of his paintings.

To conclude

Revisiting John Ruskin's poetic description of drawing, I understand his word **dirtying** as a reminder of just how uncluttered and technically simple the language of drawing can and perhaps should be.

The paper he probably meant quite literally, but if we look beyond Turner and into the bigger picture, it could just as easily refer to any surface or space with the ability to support a drawing. The sky, a rock, snow, sand, human flesh, velum, canvas, a desk top, paper and glass… there is no limit. They are all surfaces capable of receiving a drawing; they are, to put it poetically, "paper".

Finally the word **delicately**, through which I think he chose to remind us of the light, thoughtful, poetic, and intellectual measured side of the activity.

What is so attractive to me about this description is its ability to embrace the bigger picture. A picture that embraces not just invention, tactility, immediacy and economy but also repetition, cool copying and precise measurement. Drawing, I believe, takes us from the map to the skyscraper, then from the sketchbook to the fields.

Footnotes

i *Hooking Up*, Tom Wolfe, Picador 2000, ISBN 0-330-48611, pp 66–67

ii "all good drawing consists of dirtying the paper delicately"– letter written from Denmark Hill, August 30th 1855 by J Ruskin to a Mrs Brassington of Leamington

iii British Drawing, Hayward Gallery Catalogue 1984, page 9

iv *Drawing in Line*, Exhibition Catalogue, South Bank 1995

v British Drawing, Hayward Gallery Catalogue 1984

vi Queen's Collection, Windsor Castle

vii *Oxford University Gazette*, 1931

viii Collection, Ashmolean, Oxford

ix Collection, British Museum, London

x *Picasso at the Lapin Agile*, Steve Martin, Phoenix 1997, ISBN 0-75381-445-5, pp 41–43

xi *Yale French Studies: Number 84: Boundaries Writing and Drawing*, page 17. Michael Reid, Bricolage: an interview with Michael Butor

xii *The Necessity of Artspeak: The Language of Arts in the Western Tradition*, Roy Harris, Continuum 2003, ISBN 0-82646-079-8